How to Draw Cartoon Pets!

Matthew Luhn

Since 1889
GENERAL'S®
ART PRESS

Redwood City, California

This book is dedicated to all my childhood pets:

Ashley the Cat, Diamond the Dog, Goldie the Crab,

Snaps the Turtle, Mickey the Rat, Whitie the Rat,

Gipper the Fish, Slick the Salamander and Georgy the Parakeet.

How to Draw Cartoon Pets
Copyright © 2013 2nd printing by Matthew Luhn

Published by:
GENERAL'S® Art Press
Distributed by General Pencil Company, Inc.
PO Box 5311
Redwood City, CA 94063

www.GeneralPencil.com

ISBN-13: 978-0-9823671-4-8
ISBN-10: 09823671-4-7

Book Design and Story: Matthew Luhn
Editor: Katie W. Vanoncini
Printed in the United States of America

General's® Art Press is committed to the preservatio[n]
of our environment. Our books are printed in the USA
using soy based inks, in a certified green printing facilit[y]

Contents!

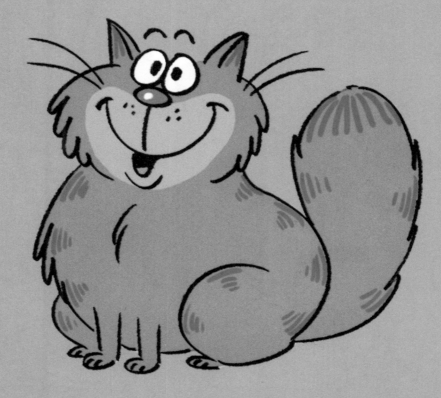

The trick to drawing cartoon cats is to give them pointy ears, triangle noses, whiskers, and a tail. When it comes to drawing the body, you can use any shape imaginable.

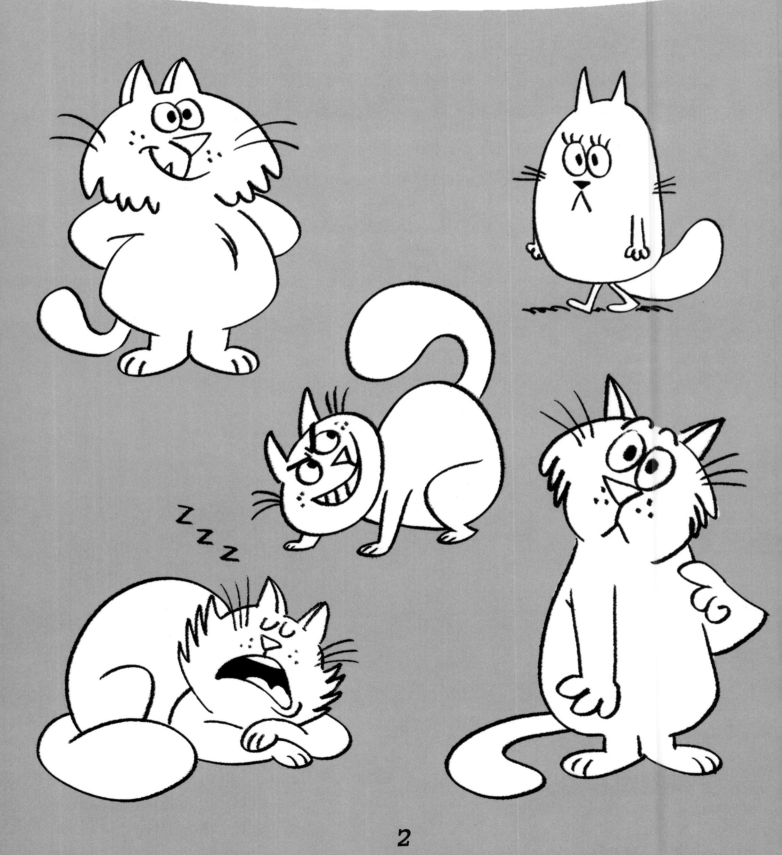

Using the shapes below, create four cats using pointy ears, triangle noses, and fur!

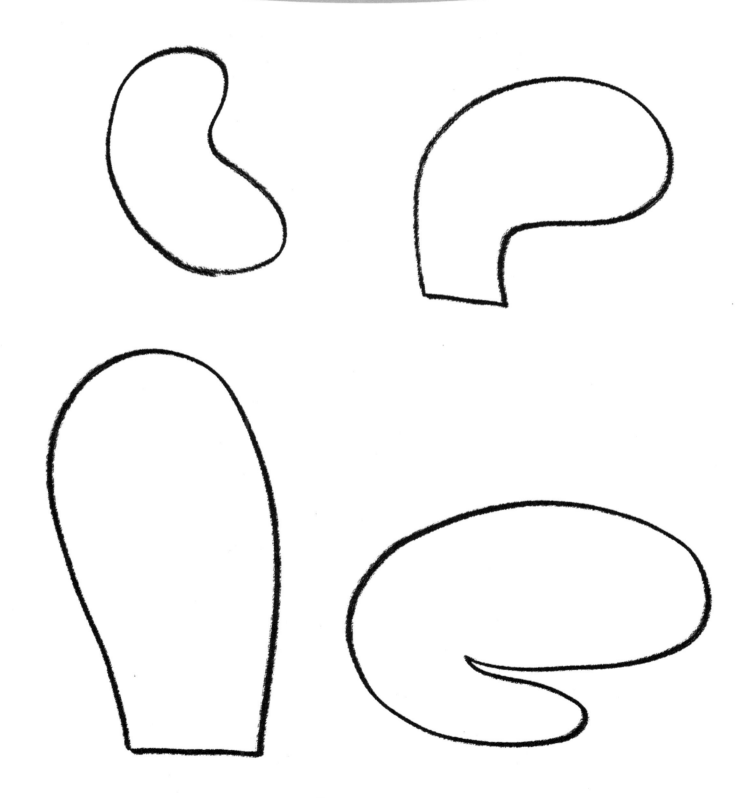

How to draw a skinny cat using shapes, expressions, and color

1 First, draw two circles.

2 Add an oval head, and a neck and body.

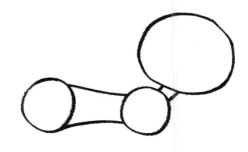

3 Draw in his back legs.

4 Now include his front legs.

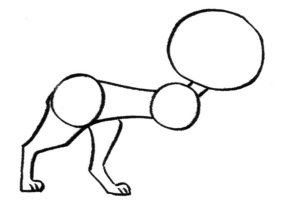

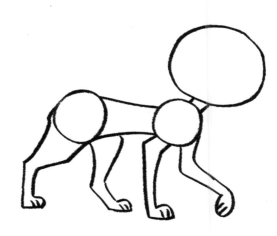

5 Add his face, tail, and whiskers.

6 Have fun coloring in your cat!

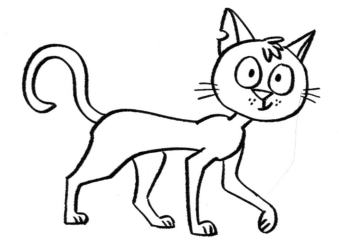

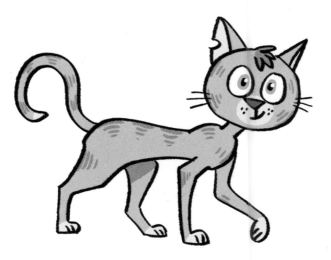

How to draw a chubby cat using shapes, expressions, and color

1 Draw an oval on a bean shape.

2 Next, add the ears and fur.

3 Draw in his tail.

4 Now include his arms and legs.

5 Draw in his face, and whiskers.

6 Have fun coloring in your cat!

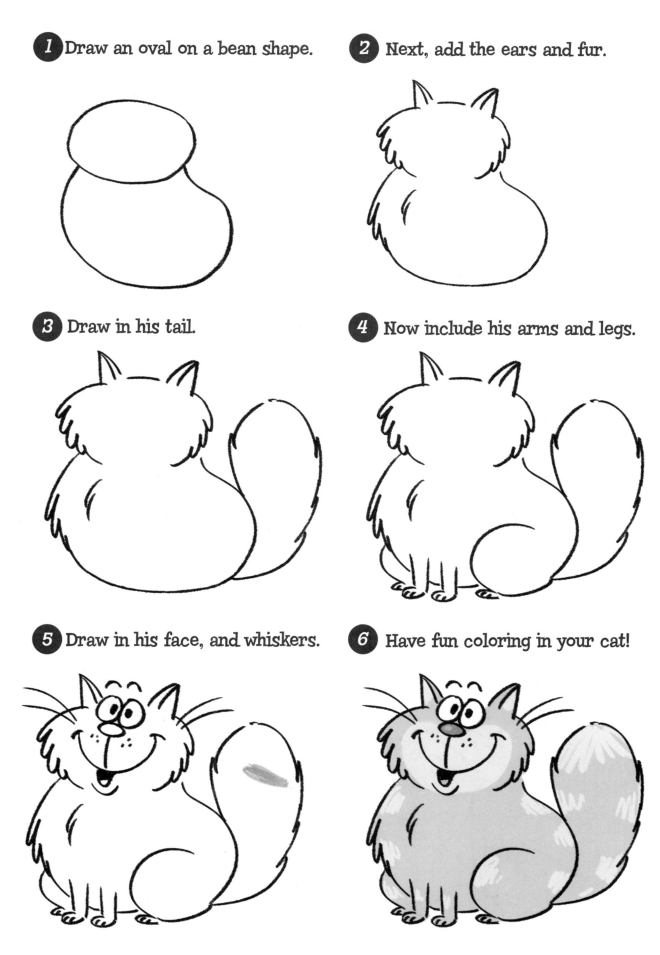

How to draw an elegant cat using shapes, expressions, and color

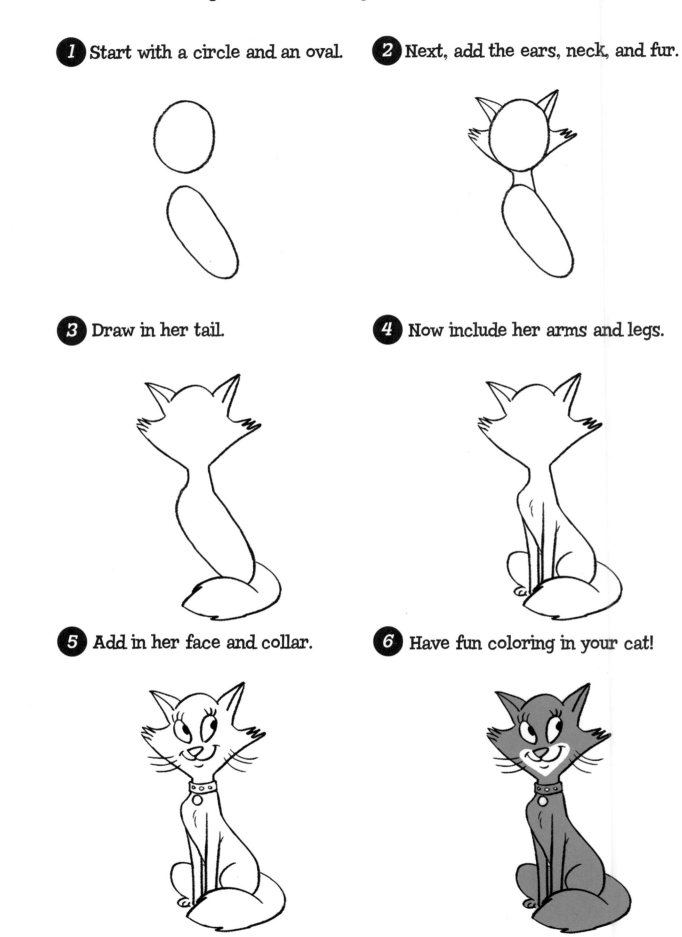

1 Start with a circle and an oval.

2 Next, add the ears, neck, and fur.

3 Draw in her tail.

4 Now include her arms and legs.

5 Add in her face and collar.

6 Have fun coloring in your cat!

6

What type of job does this cat have?
Is he an astronaut, a cowboy, or a detective?
Have fun drawing him in his work clothes!

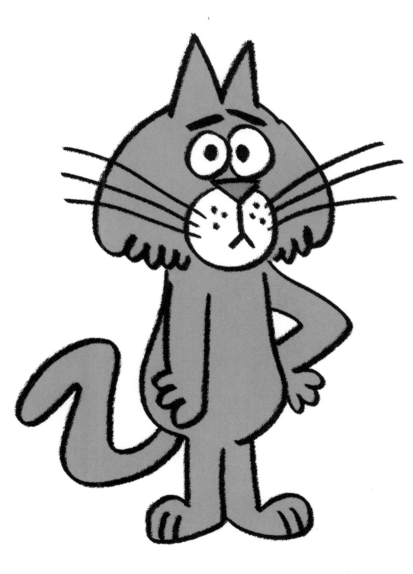

What is the cat excited about eating?
Use your imagination and draw a feast
for the cat to eat!

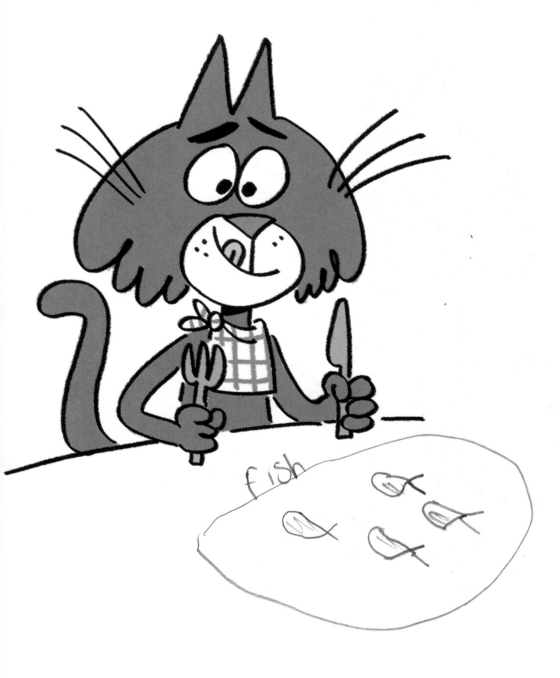

fish

HOW TO DRAW CARTOON

Birds

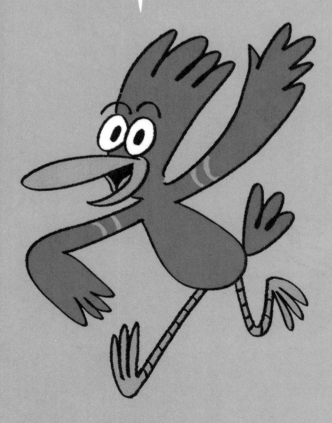

When creating cartoon birds, all you
need to draw are wings, legs, and a beak. The body
of the bird can be any shape, size, or color imaginable

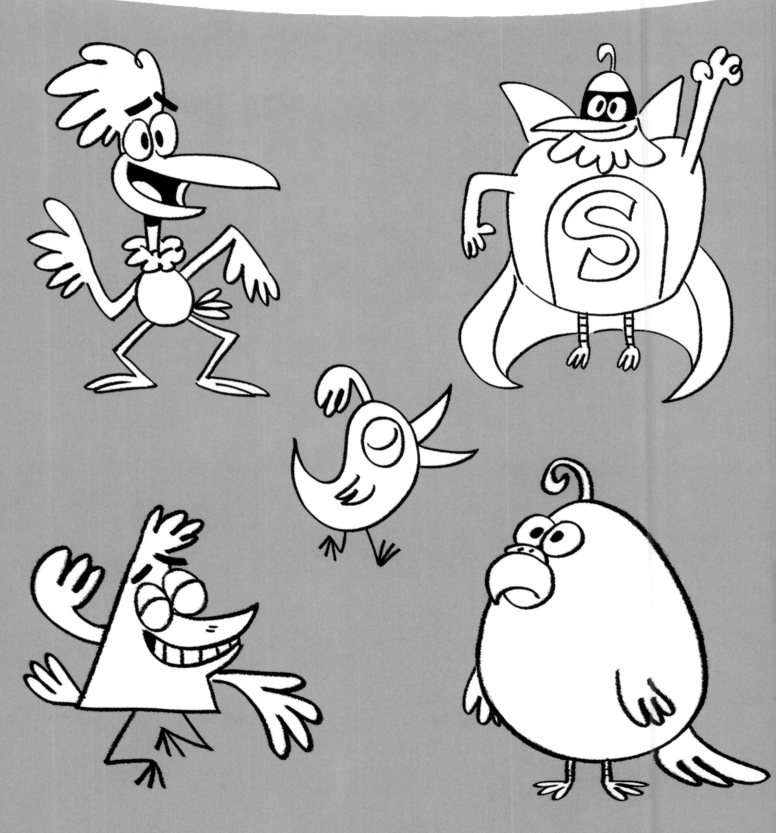

Using the shapes below, add wings, legs, and beaks to create six different cartoony birds!

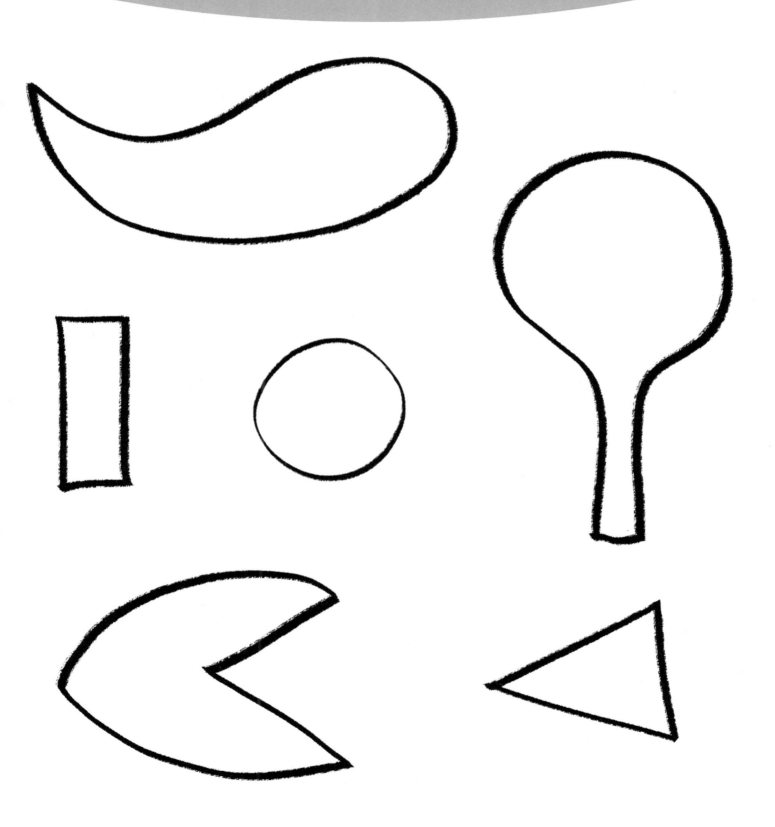

How to draw a tropical bird using shapes, expressions, and colo

 First, draw a teardrop shape.

 Add a shark fin shape for the head.

 Draw in her eyes and beak.

4 Now include her feet and wing.

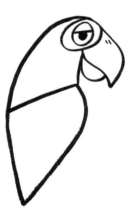

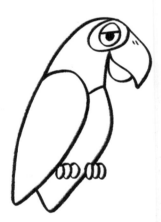

5 Add her tail and feathers.

6 Have fun coloring in your bird!

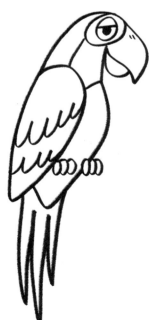

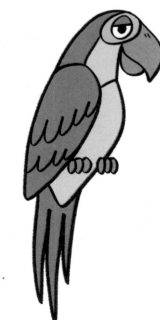

How to draw a happy bird using shapes, expressions, and color!

1 First, draw an oval shape.

2 Next, draw an oval with four bumps.

3 Draw in his wings.

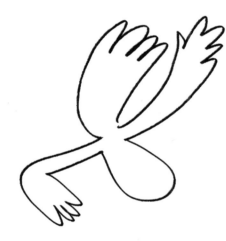

4 Now include his eyes and tail.

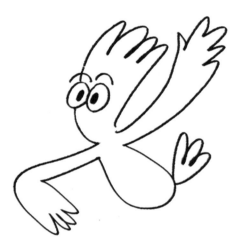

5 Draw in his beak and legs.

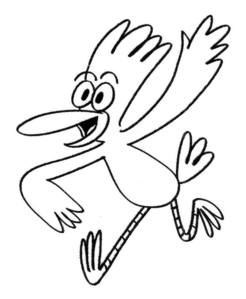

6 Have fun coloring in your bird!

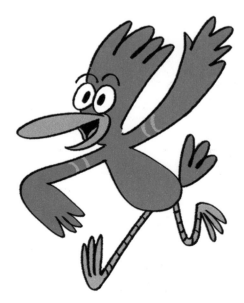

How to draw a grumpy bird using shapes, expressions, and color

 1 First, draw a square shape.

2 Next, add a head and beak.

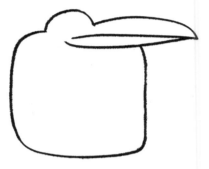

 3 Draw in her eyes and feathers.

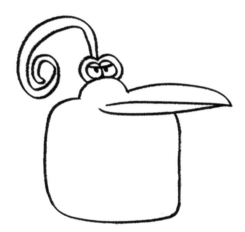

4 Add in her wings and body details.

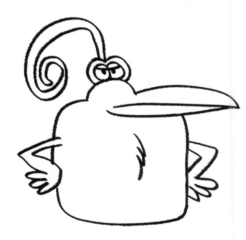

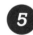 **5** Draw in her legs.

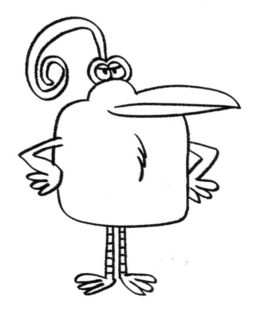

6 Have fun coloring in your bird!

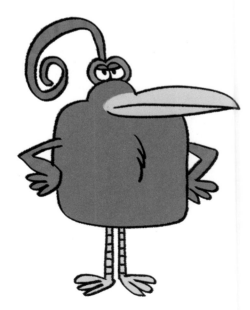

What is the bird standing in front of?
Is it a bird house, a bird cage, or a giant nest?
Have fun drawing a home for the pet bird!

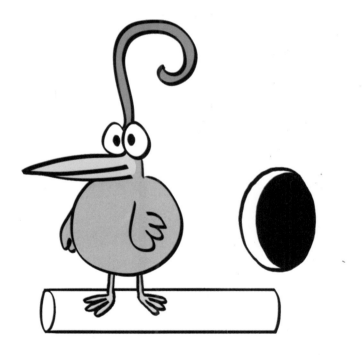

What is the bird driving?
Is it a bicycle, a race car, or an airplane?
Have fun drawing in the vehicle!

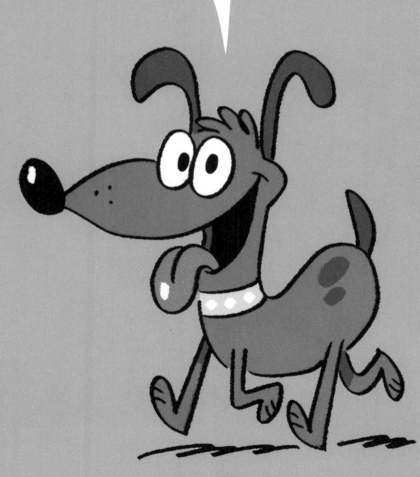

When drawing cartoon canines be sure to include distinct dog-like ears, tails, and noses. Dog noses can be long, short, pointy, or curved

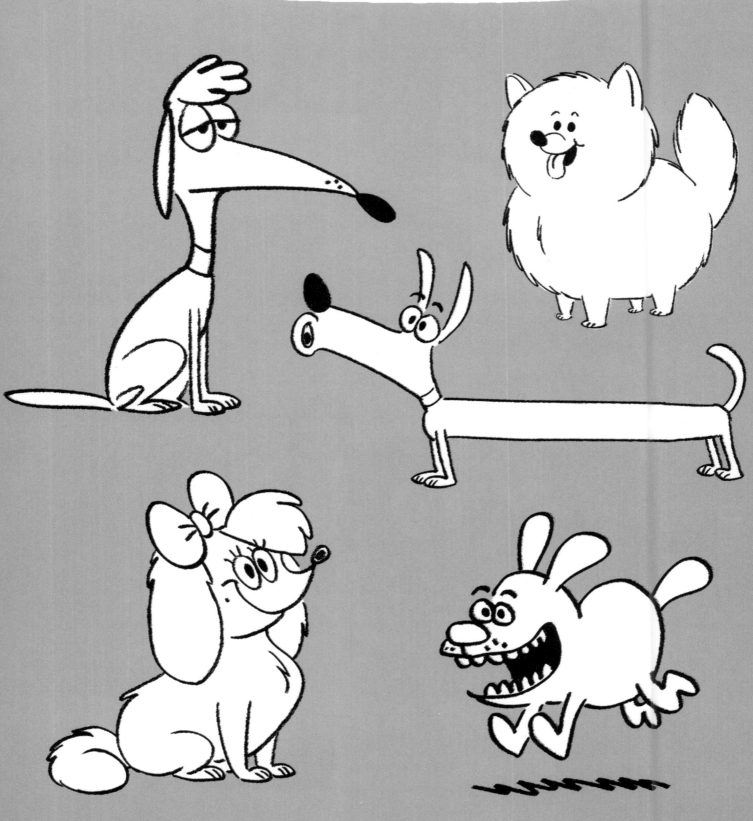

Using the shapes below, add noses, ears, and tails to create five cartoony canines!

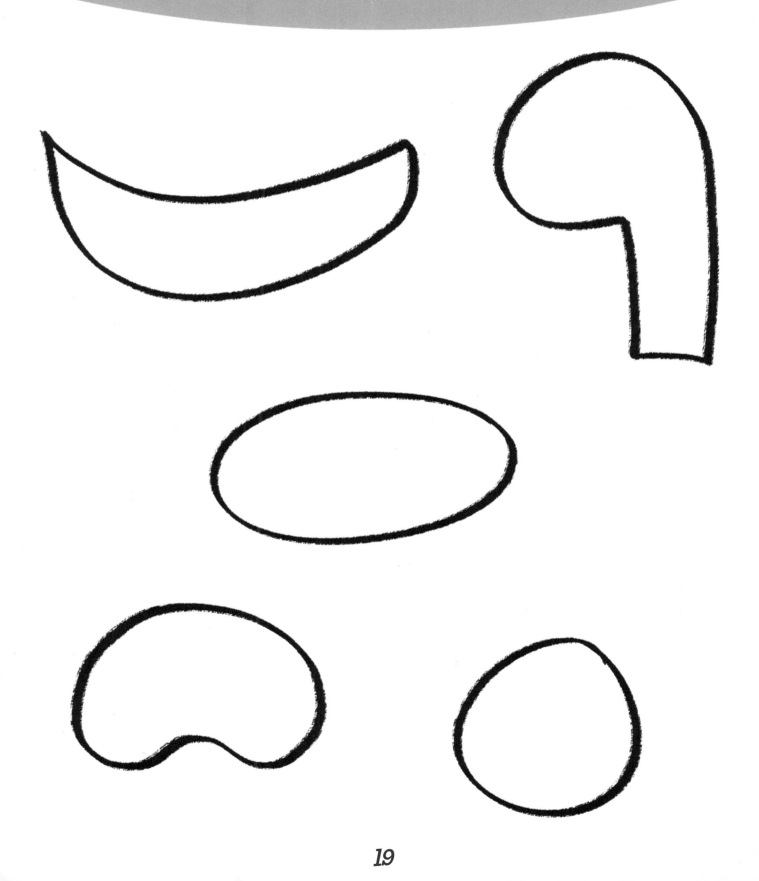

How to draw a happy dog using shapes, expressions, and color

1 First, draw a circle.

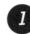

2 Add an oval body, neck, and collar.

3 Draw in his legs and tail.

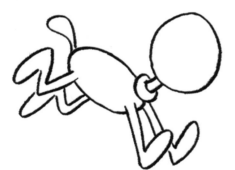

4 Now include his nose and mouth.

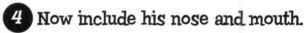

5 Add his ears, eyes, and spots.

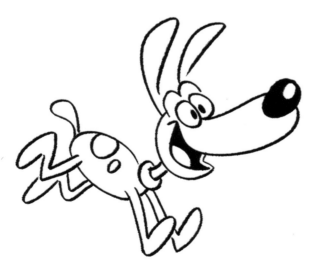

6 Have fun coloring in your dog!

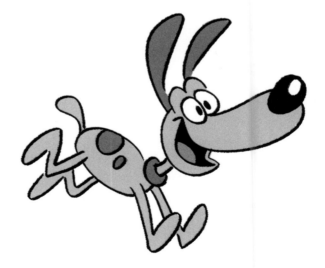

How to draw a sitting dog using shapes, expressions, and color

1 First, draw an oval and a circle.

2 Next, add the eyes and nose.

3 Draw in her hair and ears.

4 Now include her legs and fur.

5 Add her tail, bow, and dimple.

6 Have fun coloring in your dog!

How to draw a small dog using shapes, expressions, and color

1 First, draw an oval.

2 Next, draw an oval on top of that oval.

3 Draw in his legs and tail.

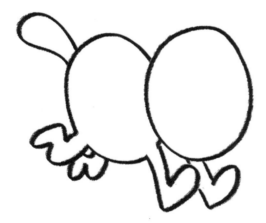

4 Now include his nose and mouth.

5 Add his eyes and ears.

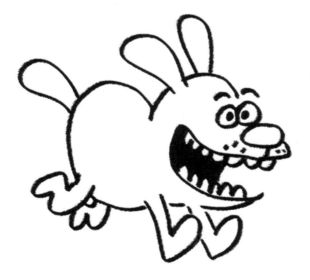

6 Have fun coloring in your dog!

Draw a cartoon of yourself walking the dog!

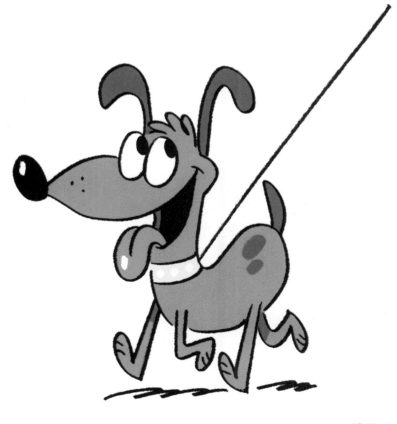

*Use your imagination,
and draw a home for the pet dog!*

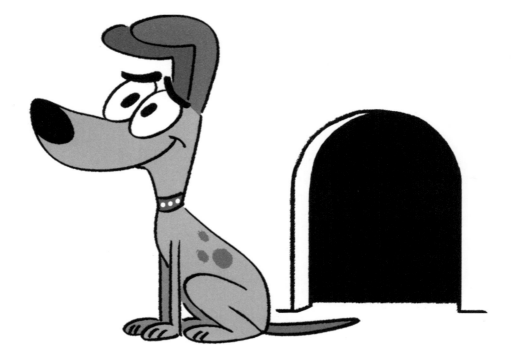

Cartoon fish are simply floating heads with fins. Have fun using the dorsal fin as hair and the pectoral fins as arms. The body of your fish can be a circle, ova, square, triangle, or any shape you can imagine!

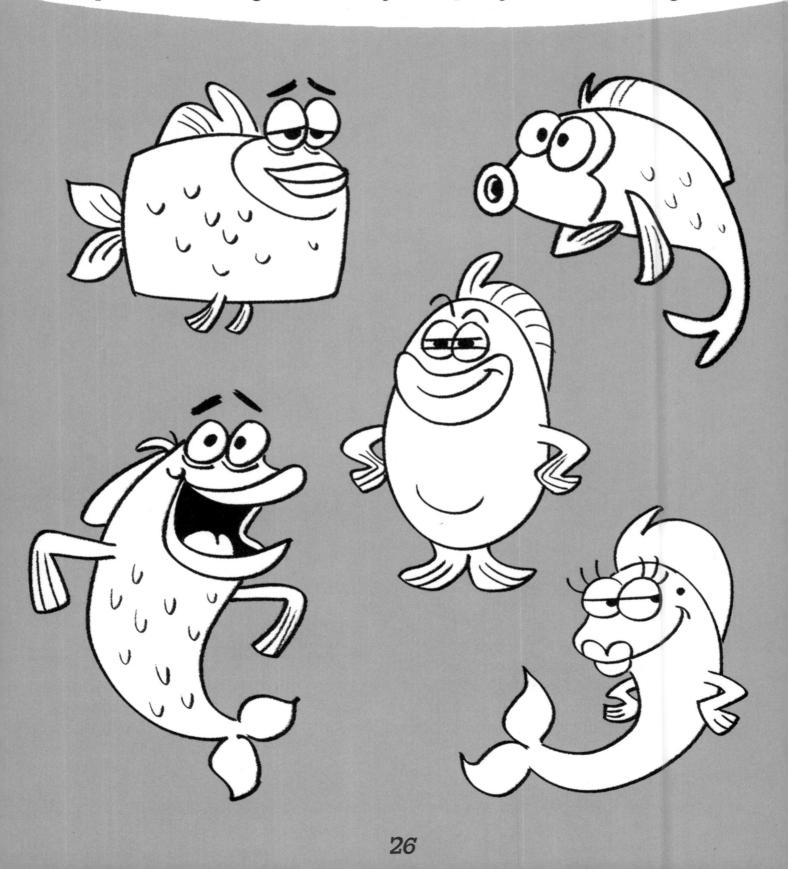

Using the shapes below, add fins and faces to create six different cartoony fish!

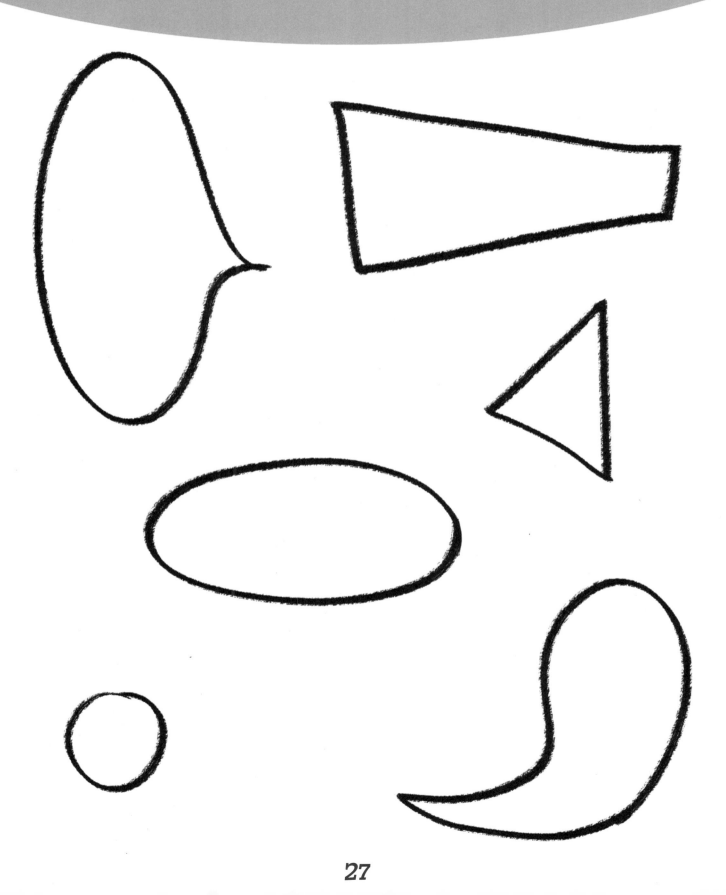

How to draw a cute fish using shapes, expressions, and color

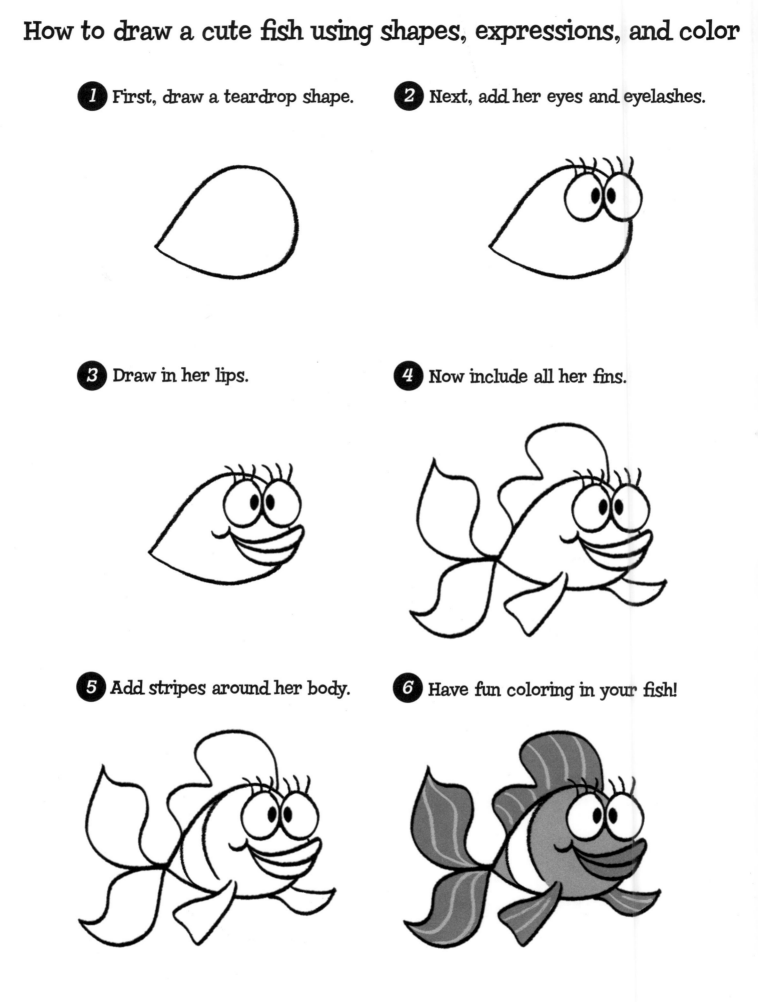

1 First, draw a teardrop shape.

2 Next, add her eyes and eyelashes.

3 Draw in her lips.

4 Now include all her fins.

5 Add stripes around her body.

6 Have fun coloring in your fish!

How to draw a smiley fish using shapes, expressions, and color

 Draw an oval shape.

Next, draw a tail fin.

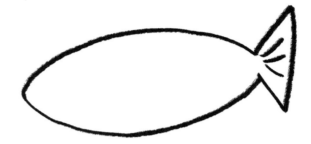

 Draw her smiley mouth.

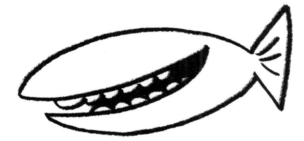

Now include her eyes.

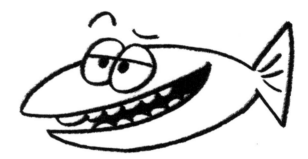

 Add in her fins.

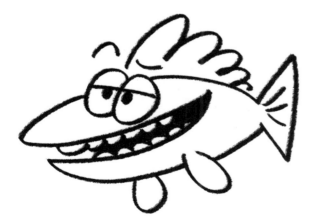

Have fun coloring in your fish!

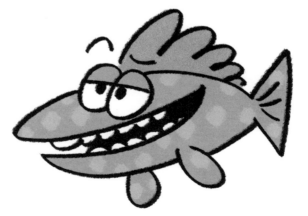

How to draw a standing fish using shapes, expressions, and color

1 First, draw an oval.

2 Next, draw the eyes of the fish.

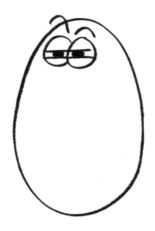

3 Draw in his fish lips.

4 Now include his arm and leg fins.

5 Add his dorsal fin and stomach.

6 Have fun coloring in your fish!

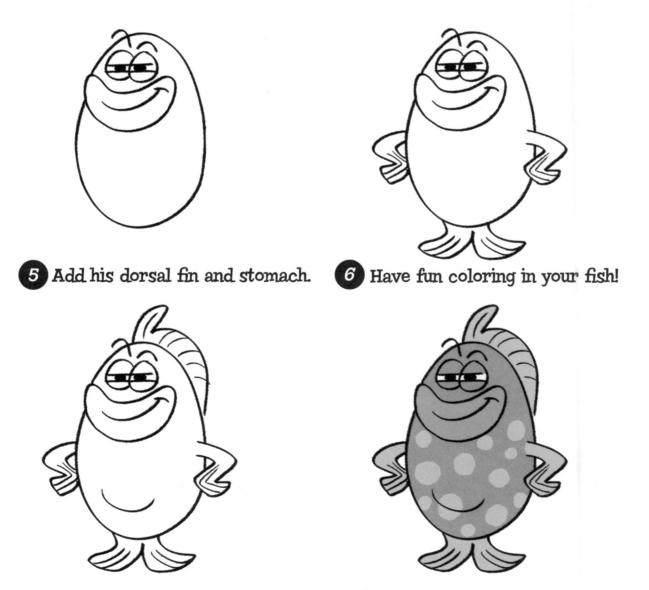

What type of family or friends does this pet fish have? Are they huge, small, or goofy looking? Have fun drawing in the other fish!

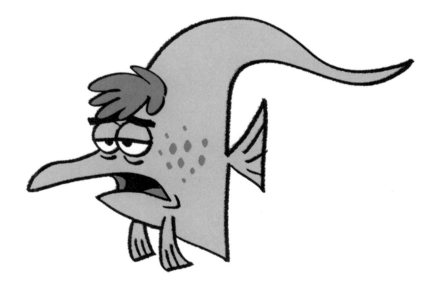

What type of home does this fish live in?
Is it a castle, a treasure chest, or a shack?
Have fun drawing a home for the pet fish!

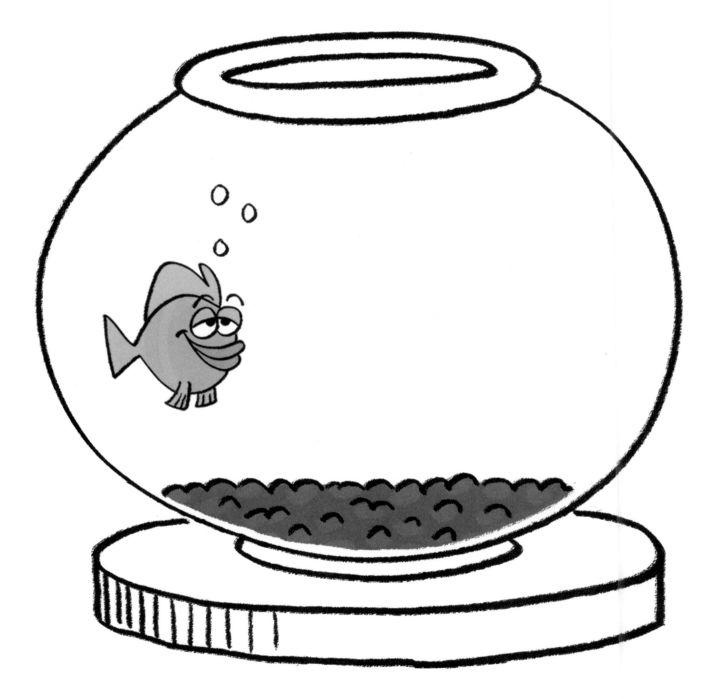

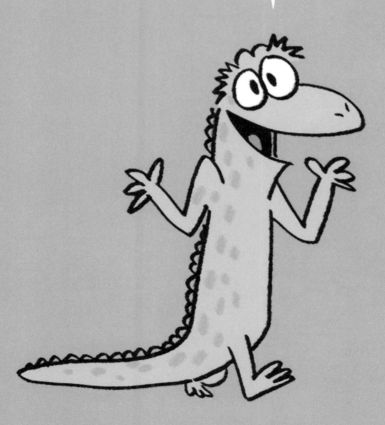

Covered with scales and patterns, reptiles all start off with a snake-type head. By adding legs to a snake you create an iguana or a lizard! By adding a shell to an iguana or lizard you create a turtle or a tortoise!

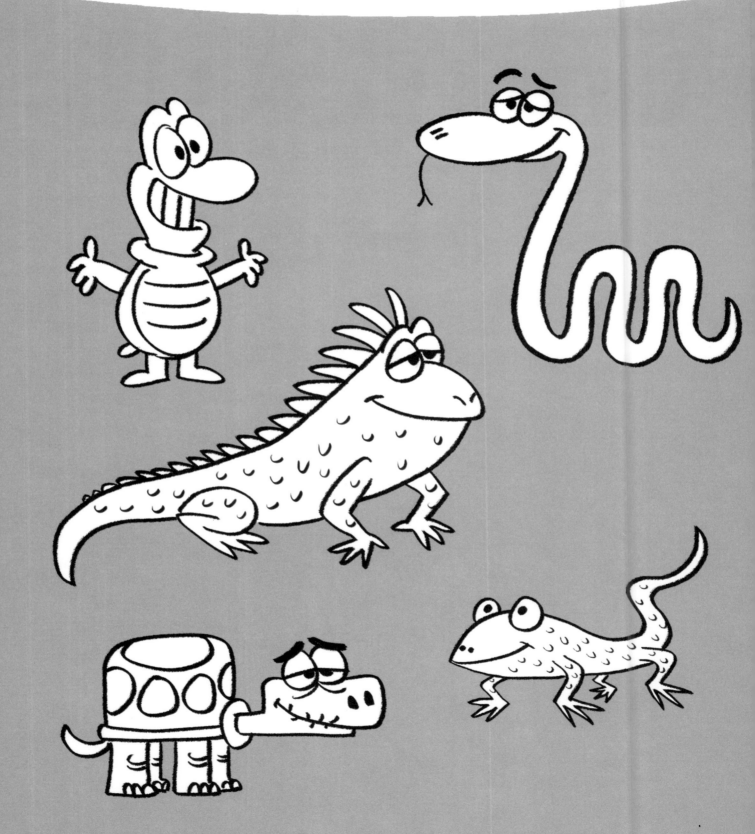

Using the shapes below, add scales and tails to create five different cartoony reptiles!

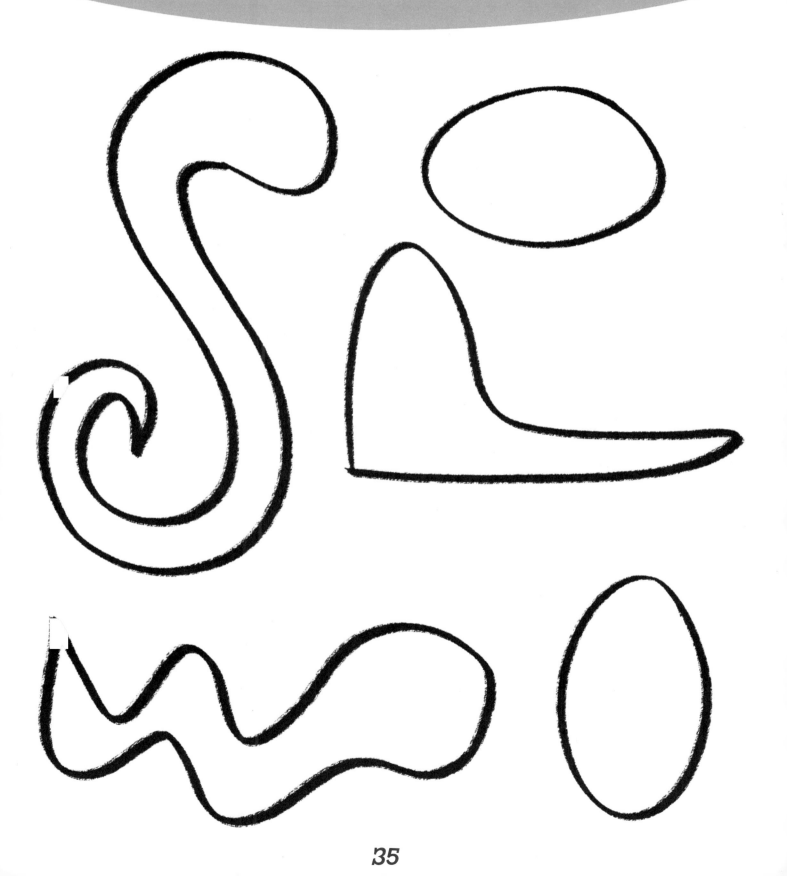

How to draw a smiley turtle using shapes, expressions, and color

1 Start with a circle.

2 Next, turn the circle into a shell.

3 Draw in his nose and mouth.

4 Now include his eyes and eyebrows.

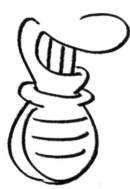

5 Add in his arms, legs, and tail.

6 Have fun coloring in your turtle!

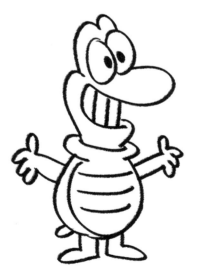

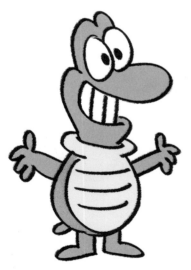

How to draw a coiled snake using shapes, expressions, and color

1 Draw a donut with shaded center. **2** Add another donut shape below.

3 Draw in his head and mouth. **4** Now include his eyes and eyebrows.

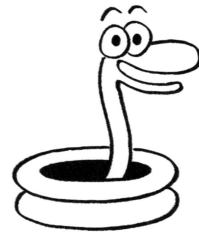

5 Add his tail, smile, and nostrils. **6** Have fun coloring in your snake!

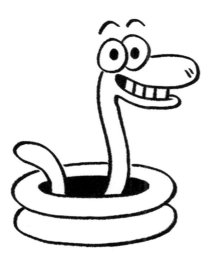

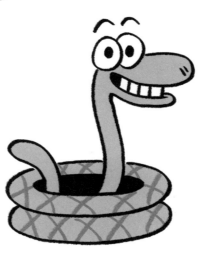

How to draw a happy gecko using shapes, expressions, and color

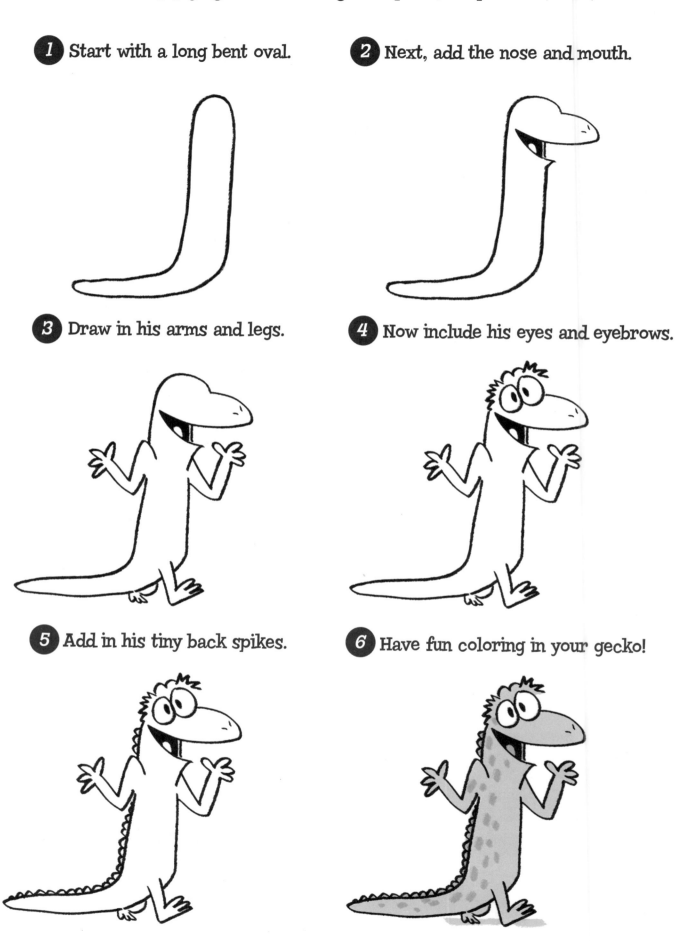

1 Start with a long bent oval.

2 Next, add the nose and mouth.

3 Draw in his arms and legs.

4 Now include his eyes and eyebrows.

5 Add in his tiny back spikes.

6 Have fun coloring in your gecko!

Is the tortoise going to win the race? Draw the other pets racing against this land-dwelling reptile!

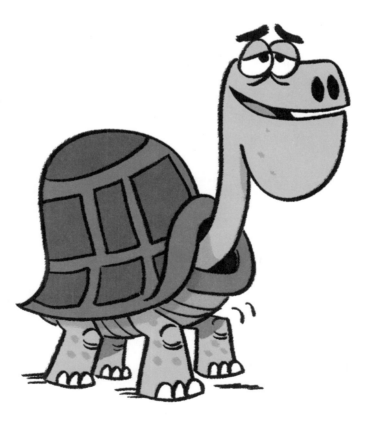

Have fun drawing what the pet snake received on his birthday!

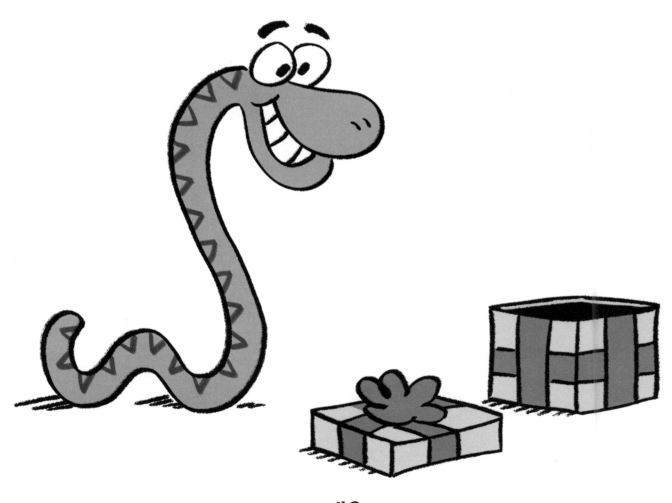

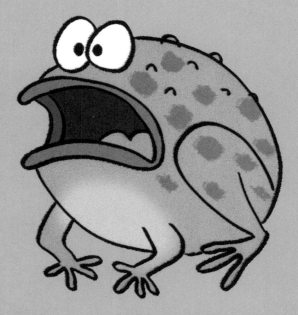

When drawing frogs or toads include webbed limbs and upper lips. When drawing salamanders or newts, simply start with a snake body and add on arms and legs. Have fun drawing these water and land amphibians!

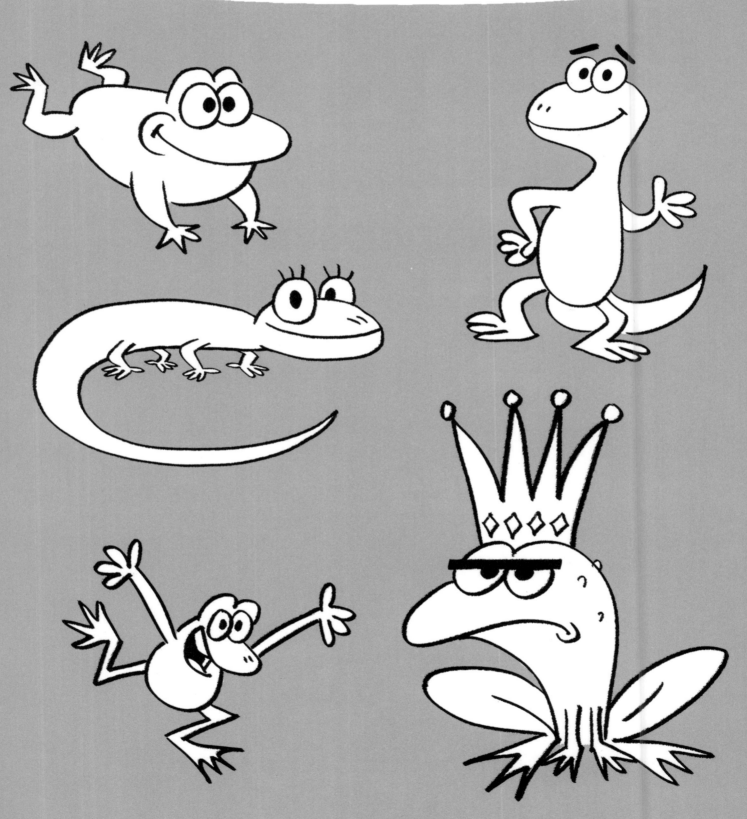

Using the shapes below add webbed feet and upper lips to create four animated amphibians!

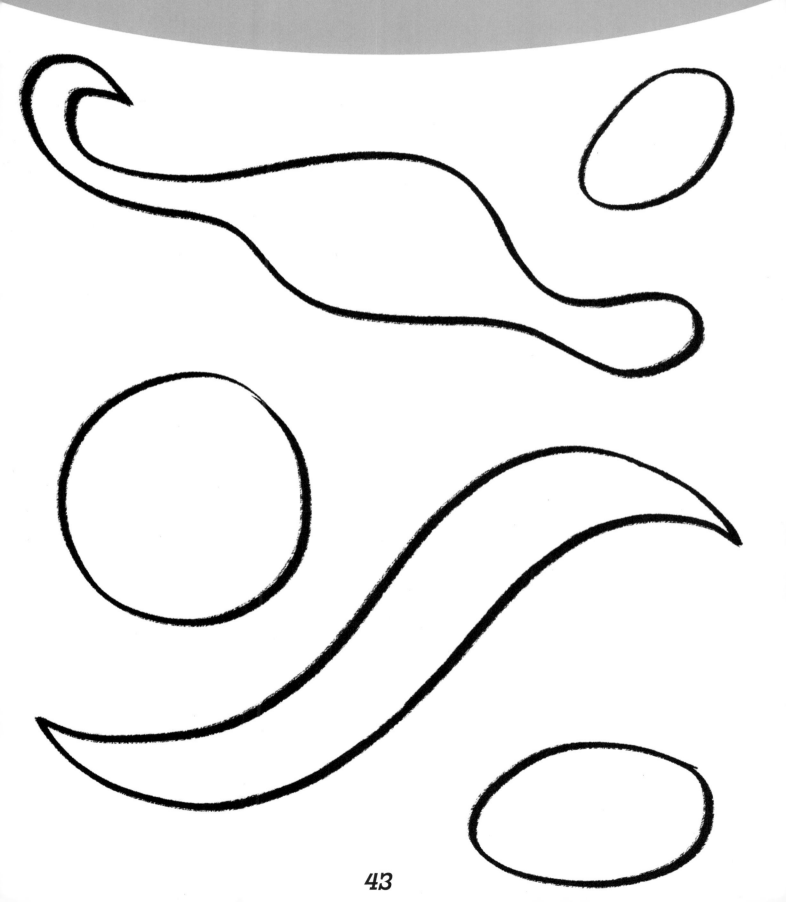

How to draw a jumping frog using shapes, expressions, and color

1 First, draw a cirlce.

2 Now draw a circle behind that circle.

3 Draw in his eyes and mouth.

4 Include his legs and feet.

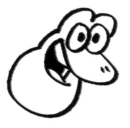

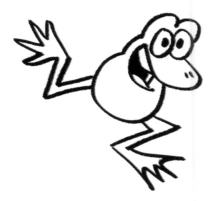

5 Add his arms and hands.

6 Have fun coloring in your frog!

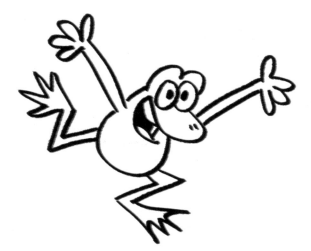

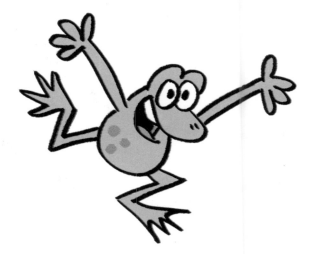

How to draw a salamander using shapes, expressions, and color

1 First, draw an oval for her body. **2** Add her head, neck, and tail.

3 Draw in her eyes and mouth. **4** Now include her arms.

5 Draw in her legs. **6** Have fun coloring in your salamander!

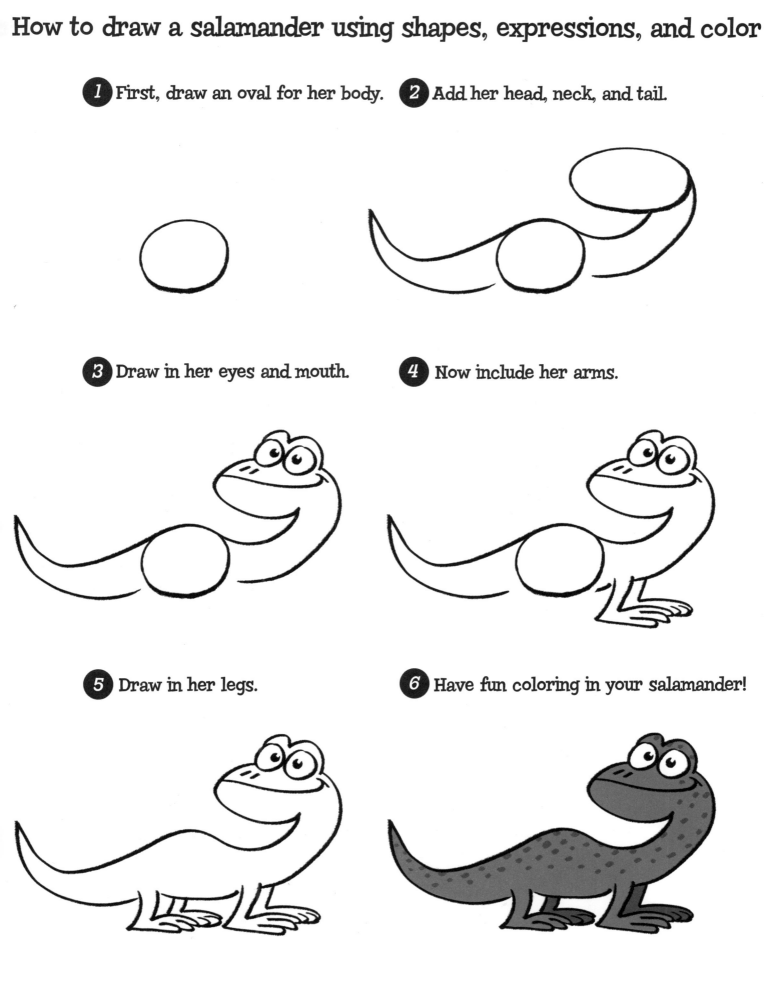

How to draw a green toad using shapes, expressions, and color

1 First, draw a circle.

2 Add his eyes and eyebrows.

3 Draw in his mouth.

4 Now include his arms.

5 Add his legs and warts.

6 Have fun coloring in your toad!

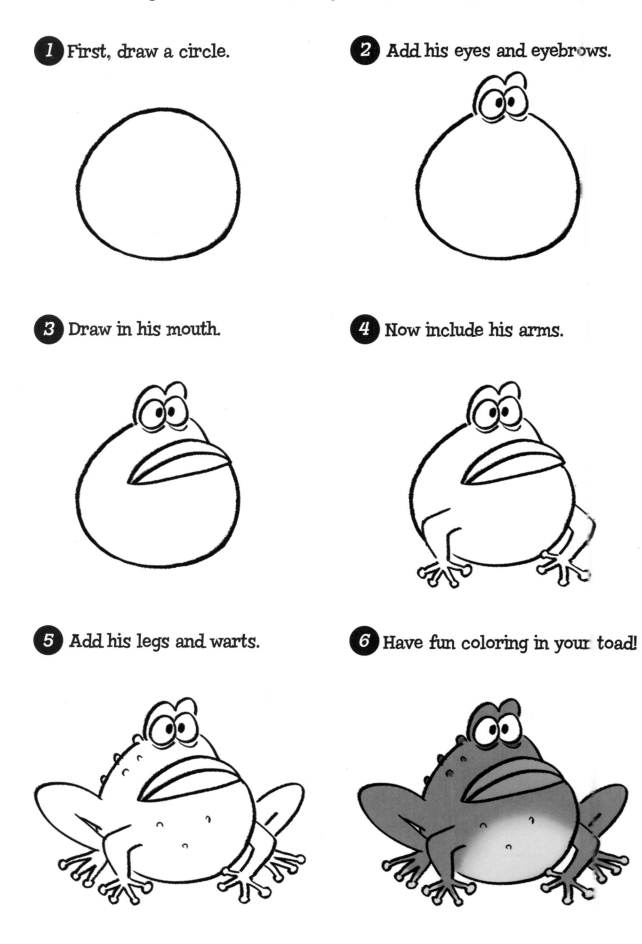

Does the newt live in a terrarium, the wild, or is he on vacation in the Bahamas? Have fun drawing in his surroundings!

What is this frog's tongue touching?
Is it a fly, a hamburger, or an elephant?
Draw what the pet frog caught for lunch!

HOW TO DRAW CARTOON

Critters

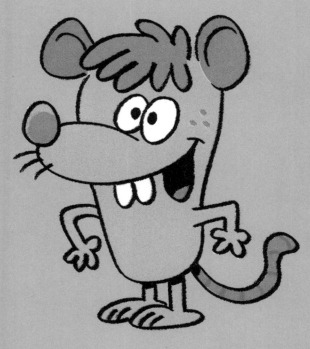

Furry critters like bunnies, mice, hamsters, and rats make great cartoon characters. Have fun adding on big floppy ears, pointy noses and funny tails to any shape imaginable to create some cartoon critters!

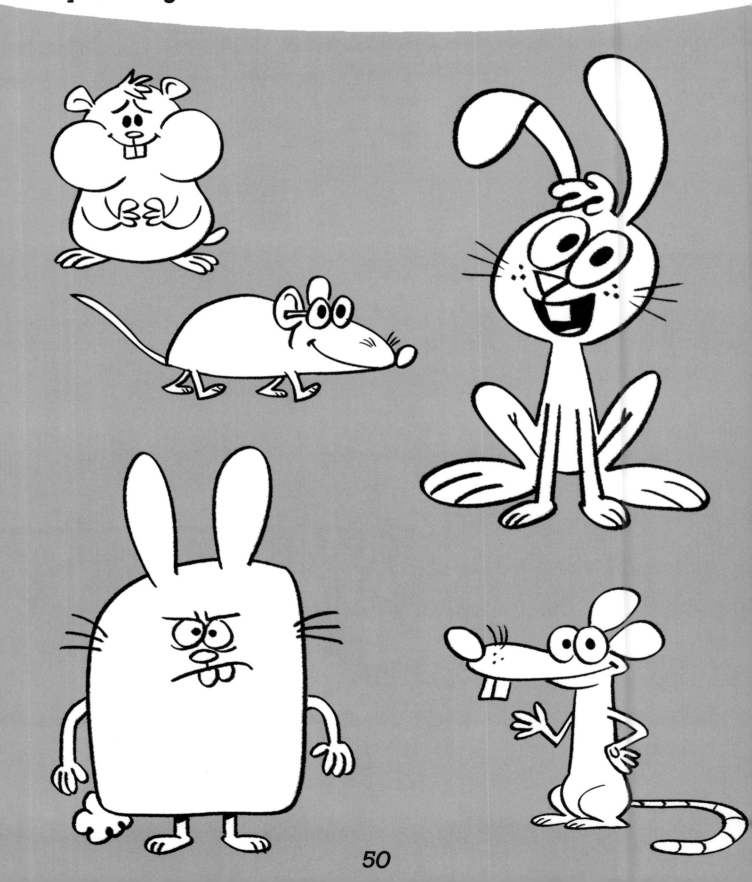

Using the shapes below, add tails, pointy noses, whiskers, and funny ears to create five different cartoony critters!

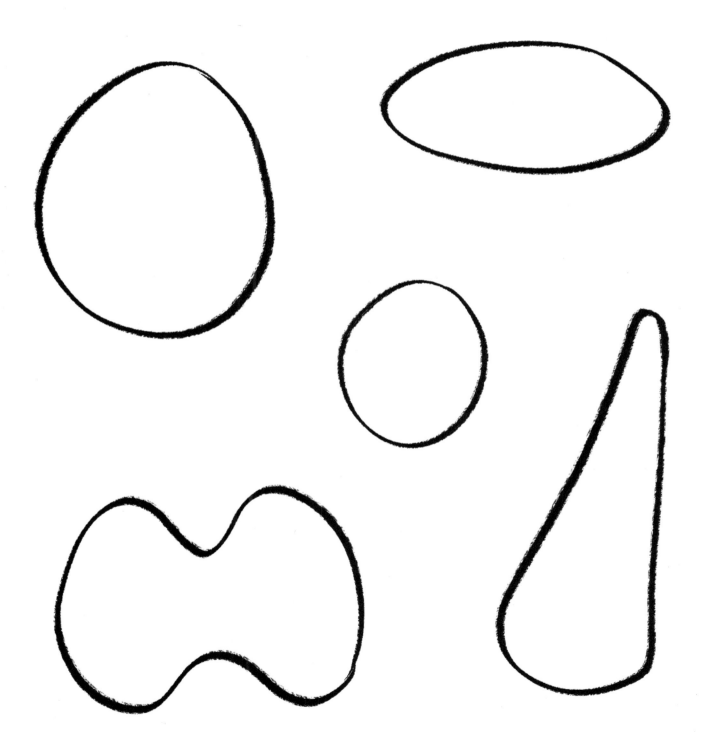

How to draw a cute hamster using shapes, expressions, and colo

1 Draw an oval on top of a big oval. **2** Next, draw chubby cheeks.

3 Include his eyes, nose, and mouth. **4** Add his arms and feet.

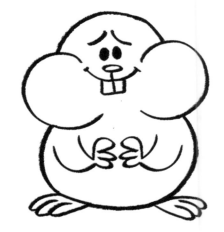

5 Add his ears, hair, and tail. **6** Have fun coloring in your hamster!

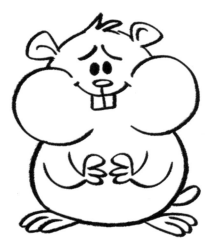

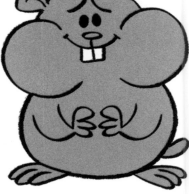

How to draw a happy bunny using shapes, expressions, and color

1 First, draw a key hole shape.

2 Next, draw his eyes, nose, and mouth.

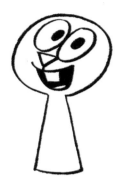

3 Draw in his legs and big feet.

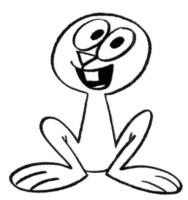

4 Now include his arms.

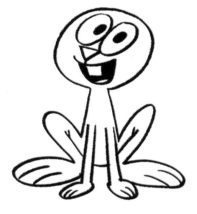

5 Add his ears, hair, and whiskers.

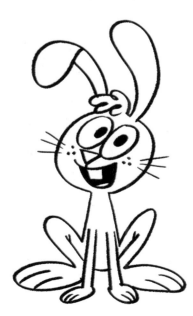

6 Have fun coloring in your bunny!

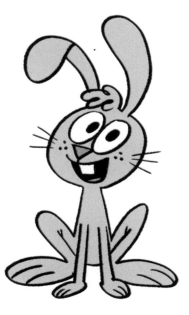

How to draw a happy rat using shapes, expressions, and color

1 First, draw an oval.

2 Next, add his eyes, nose, and mouth.

3 Draw in his legs and fur.

4 Now include his arms.

5 Add his ears, whiskers, and tail.

6 Have fun coloring in your rat!

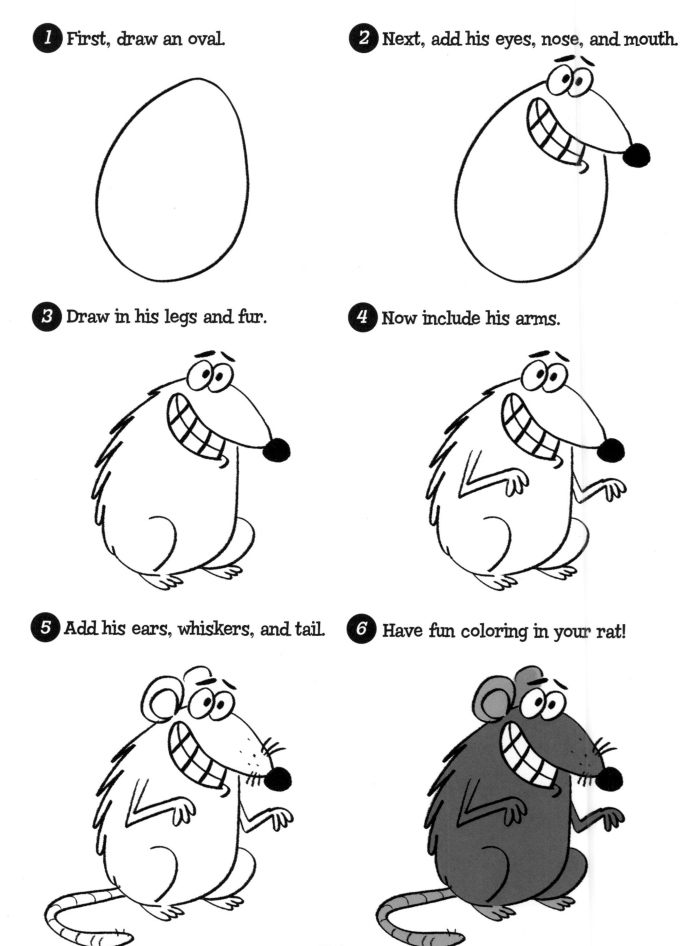

What is the hamster running in?
Is it an exercise wheel, a hamster ball, or a
treadmill? Draw in the type of exercise machine
the hamster is working out on!

What is this mouse looking at?
Is it chocolate cake, a day old pickle, or
stinky cheese? Draw what the mouse is excited
about eating for dinner!

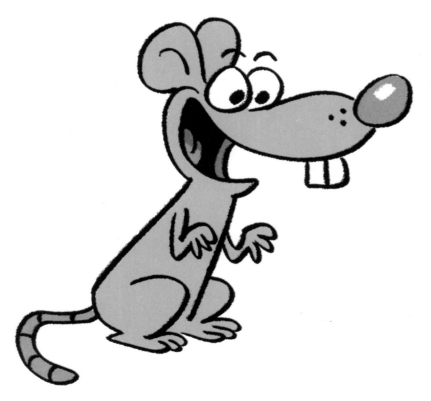

HOW TO DRAW CARTOON

Farm Pets

From sheep to pigs to ponies to roosters, there's a barn full of farm animals you can turn into cartoons by using circles, squares, and triangles!

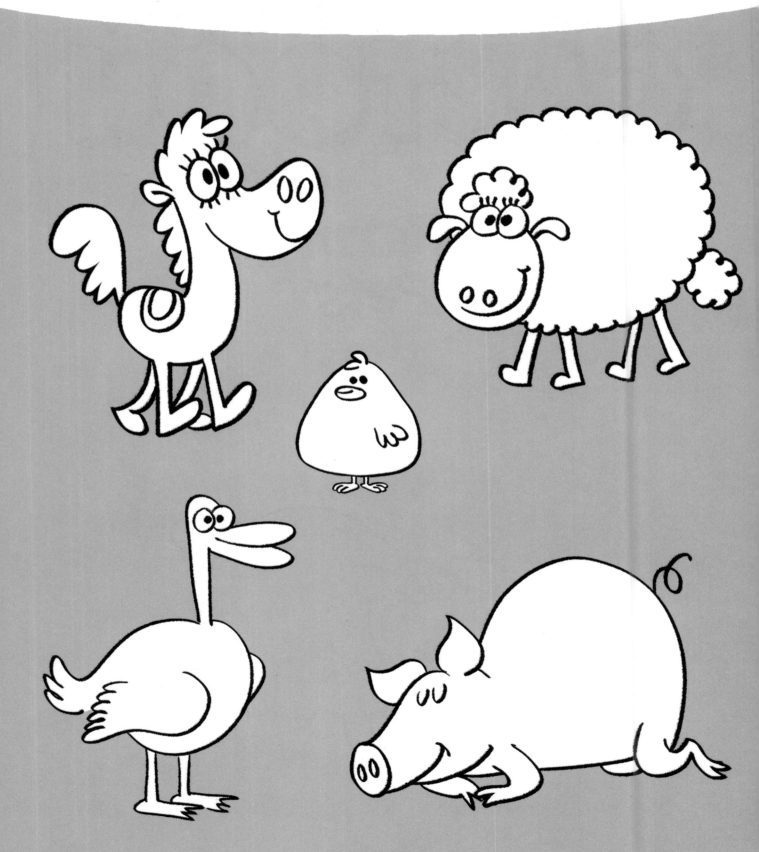

Using the shapes below have fun adding snouts, hooves, and feathers to create five different funny farm pets !

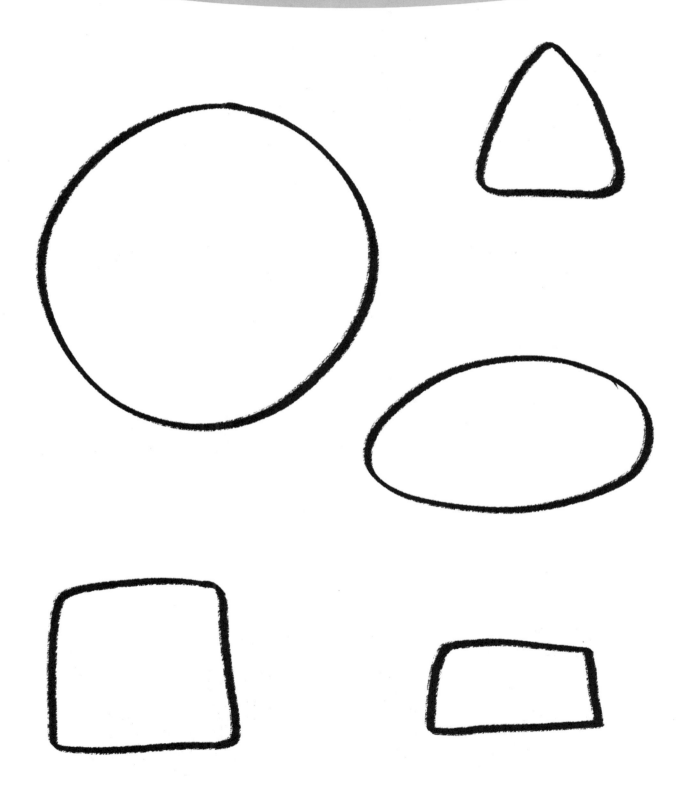

How to draw a puffy sheep using shapes, expressions, and color

1 First, draw an oval puffy cloud. **2** Next, add an oval for her head.

3 Draw in her smile, eyes, and ears. **4** Now include her legs.

5 Add her tail, hair, and nostrils. **6** Have fun coloring in your sheep!

How to draw a happy pig using shapes, expressions, and color

1 Draw a circle for the pig's body.

2 Next, add an oval for his head.

3 Draw in his nose and mouth.

4 Now include his legs.

5 Draw in his eyes, ears, and tail.

6 Have fun coloring in your pig!

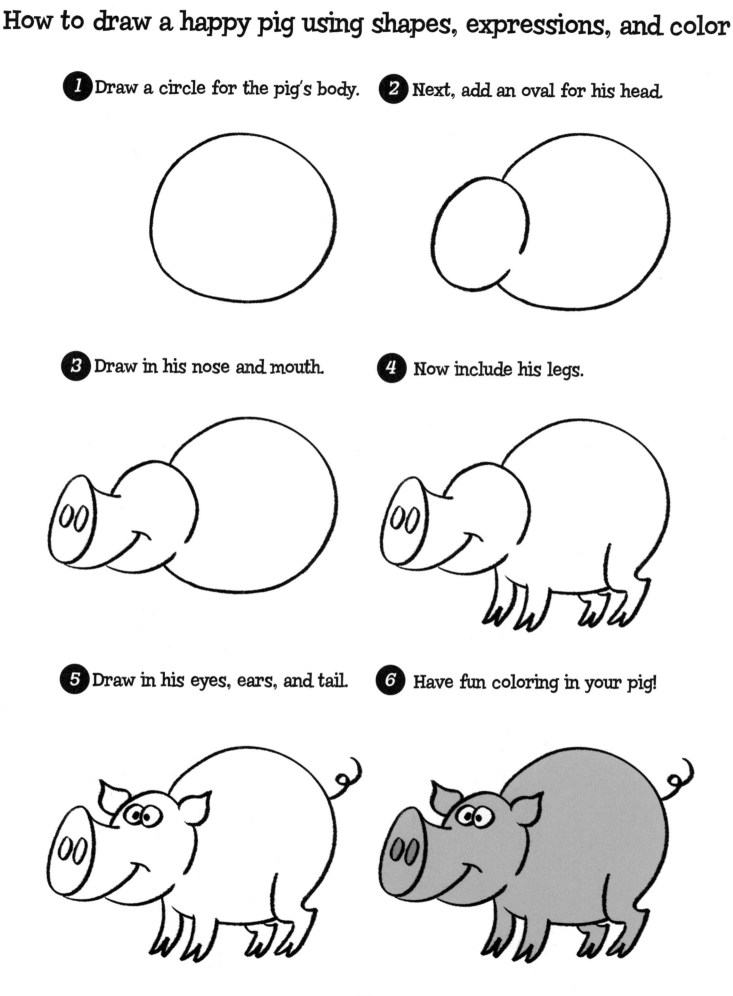

How to draw a pony using shapes, expressions, and color

1 Draw an oval and a bean shape.

2 Add a cylinder shape connecting the two

3 Draw in her legs.

4 Now include her eyes, nostrils, and mout

5 Add her ear and mane.

6 Have fun coloring in your pony!

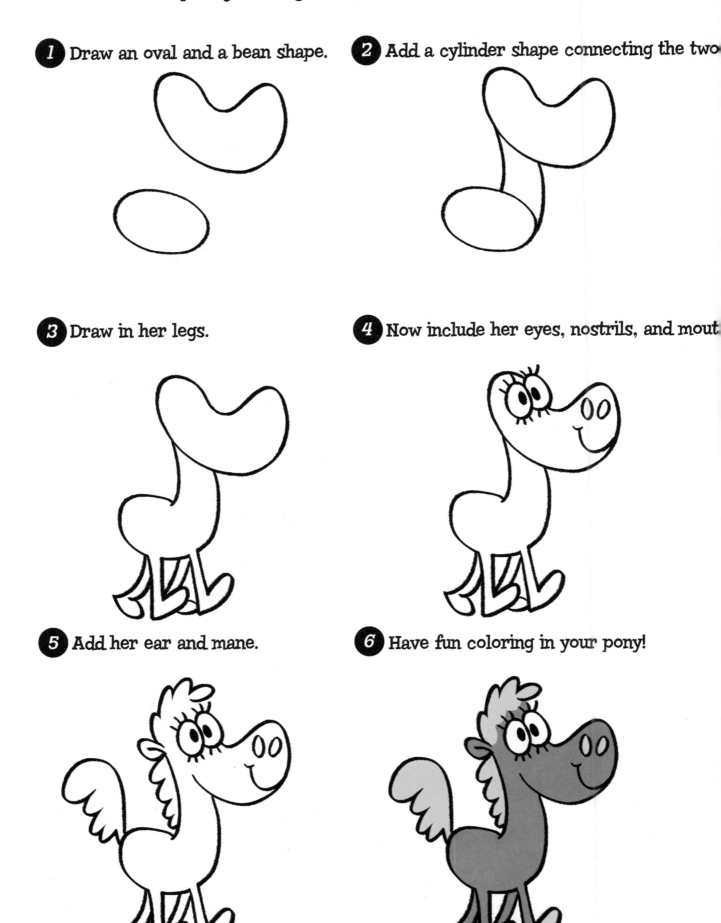

Draw the rooster strutting around
the farm with his wife and kids.

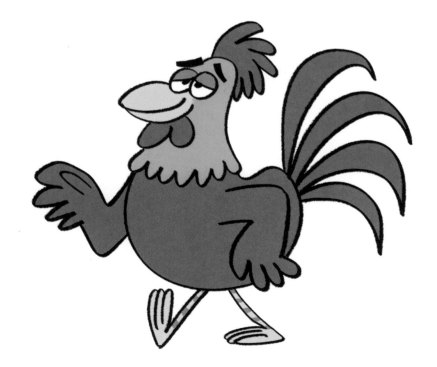

Is it five, ten, or a hundred eggs that Mrs. Duck is sitting on waiting to hatch? Have fun drawing in as many eggs as you wish!

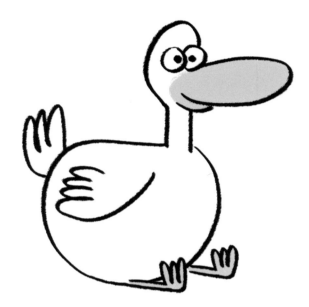

This section is dedicated to your own

CARTOON

Pets!

My Family

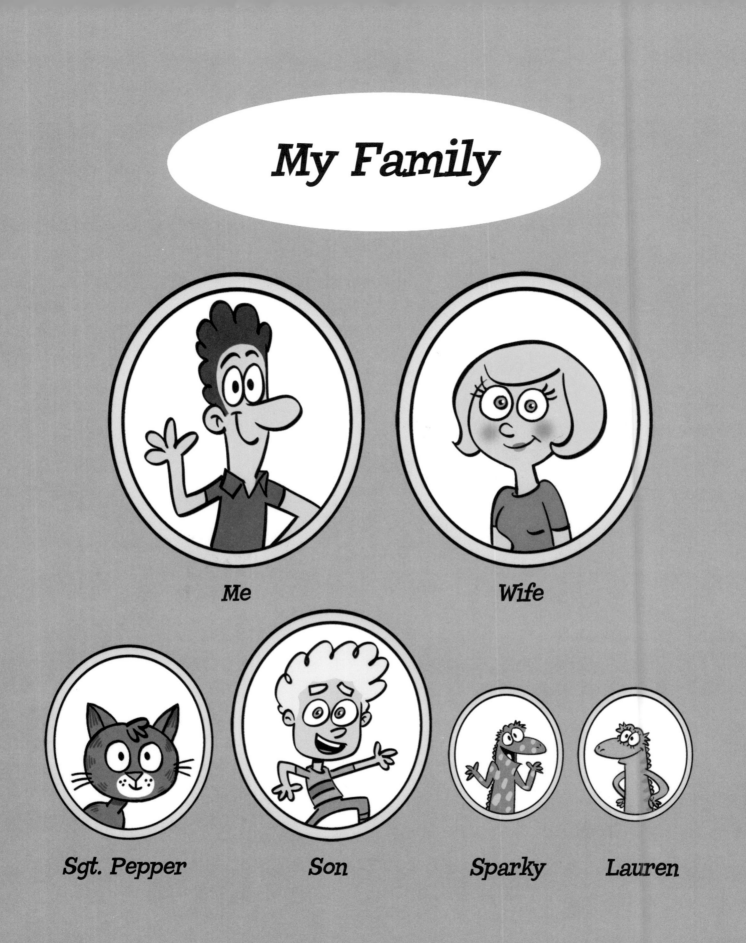

Your Family

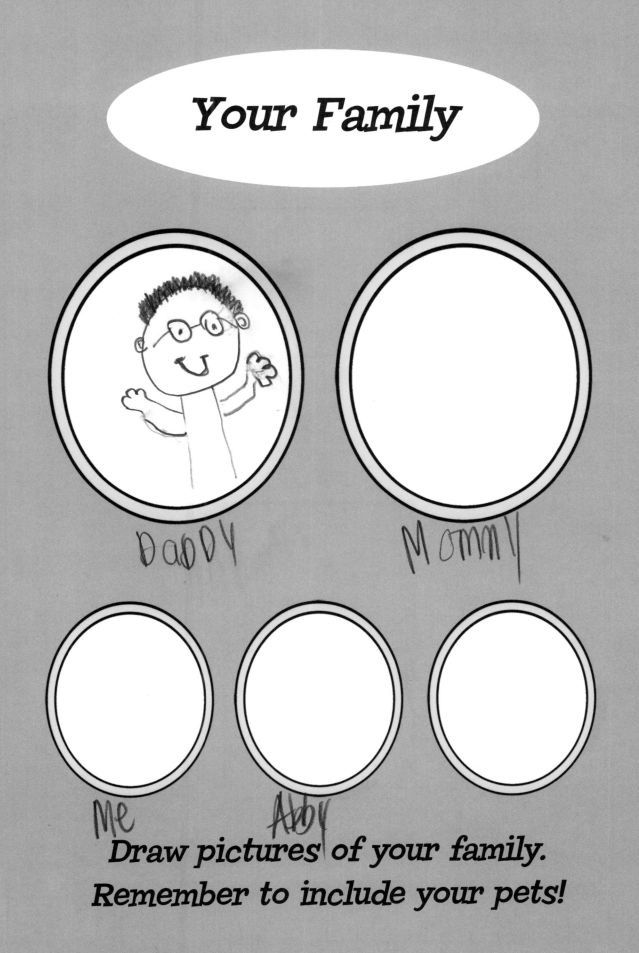

DaDDY

MommY

Me

Abby

Draw pictures of your family.
Remember to include your pets!

Snapshots!

Draw yourself and your pet taking goofy photos in the photo booth.

Home Sweet Home!

Draw a picture of your pet
in his or her home.

Roadtrip!

Draw a picture of yourself and
your pet on vacation.

Draw your pet as a superhero!

Pet Celebrity

Draw a picture of your pet
as a famous celebrity!